THE SKY IS THE LIMIT

Photos by April Sanford-Meyer

THIS BOOK IS DEDICATED TO MY MOTHER, LOUISE SANFORD. (1932-1999)

SHE LOVED TAKING PHOTOS ON SUNRISES AND SUNSETS.

SHE WAS AND IS ALWAYS MY LIGHT, MY INSPIRATION, AND MY STRENGTH.

WITH ALL MY LOVE MOM.

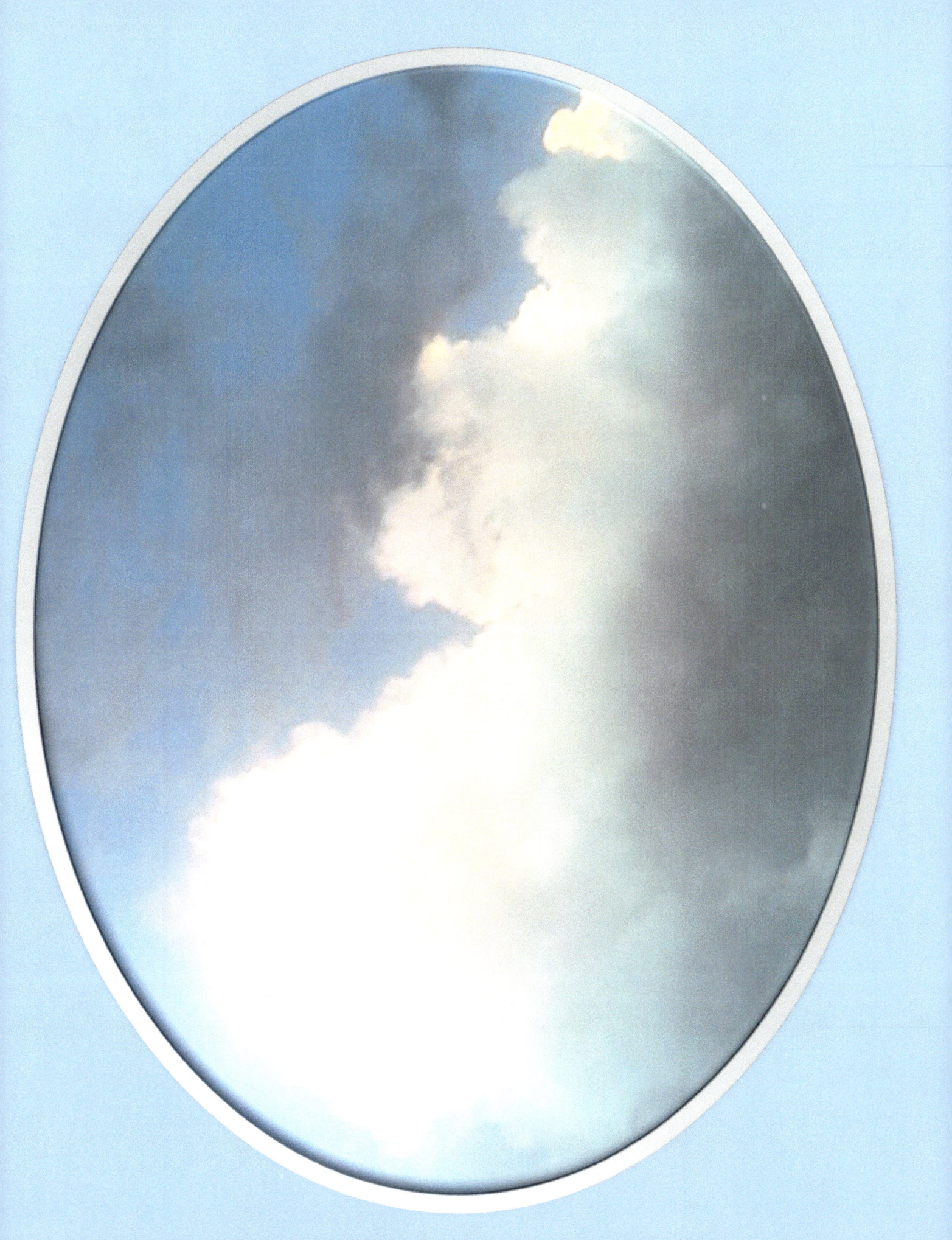

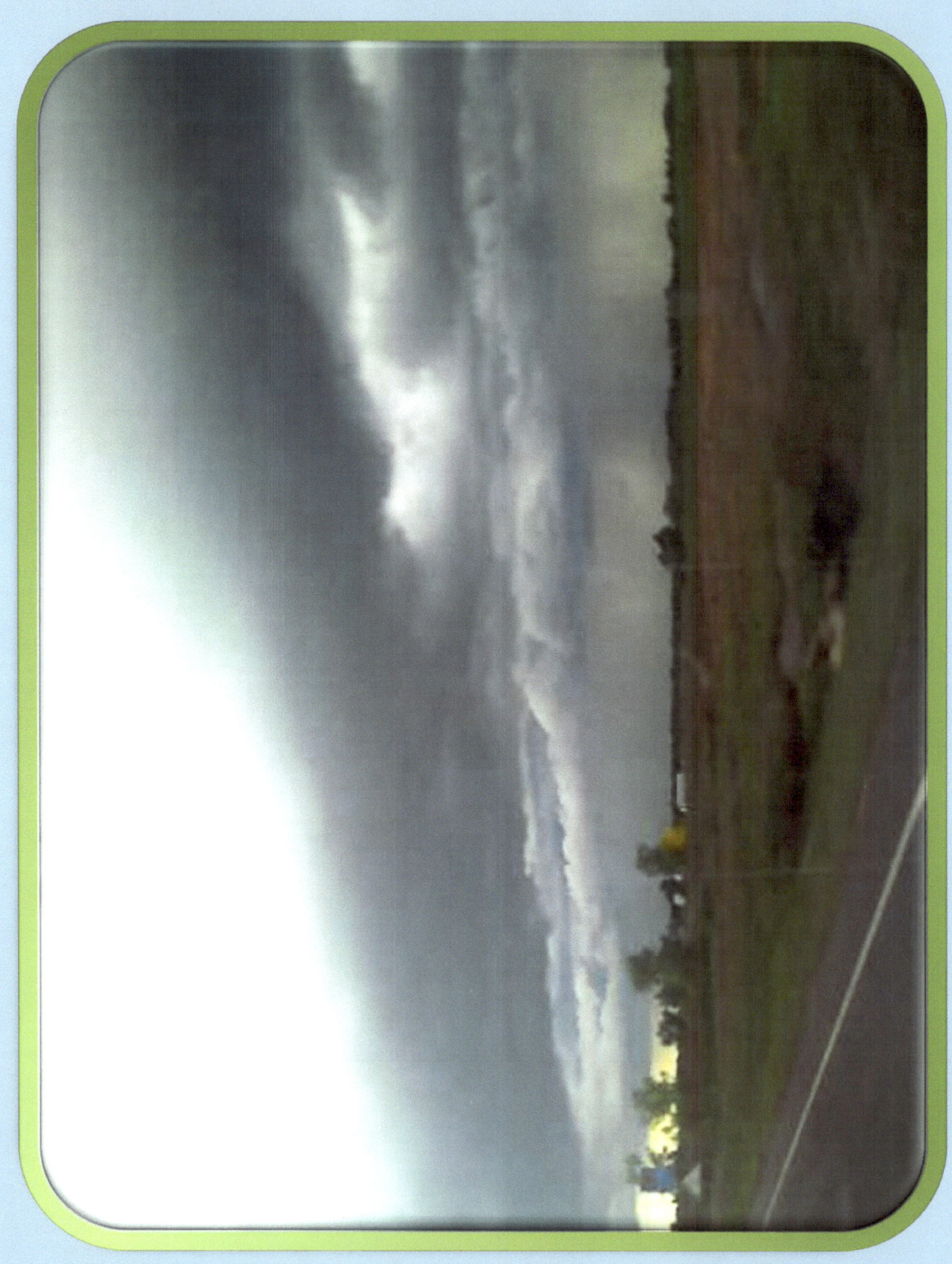

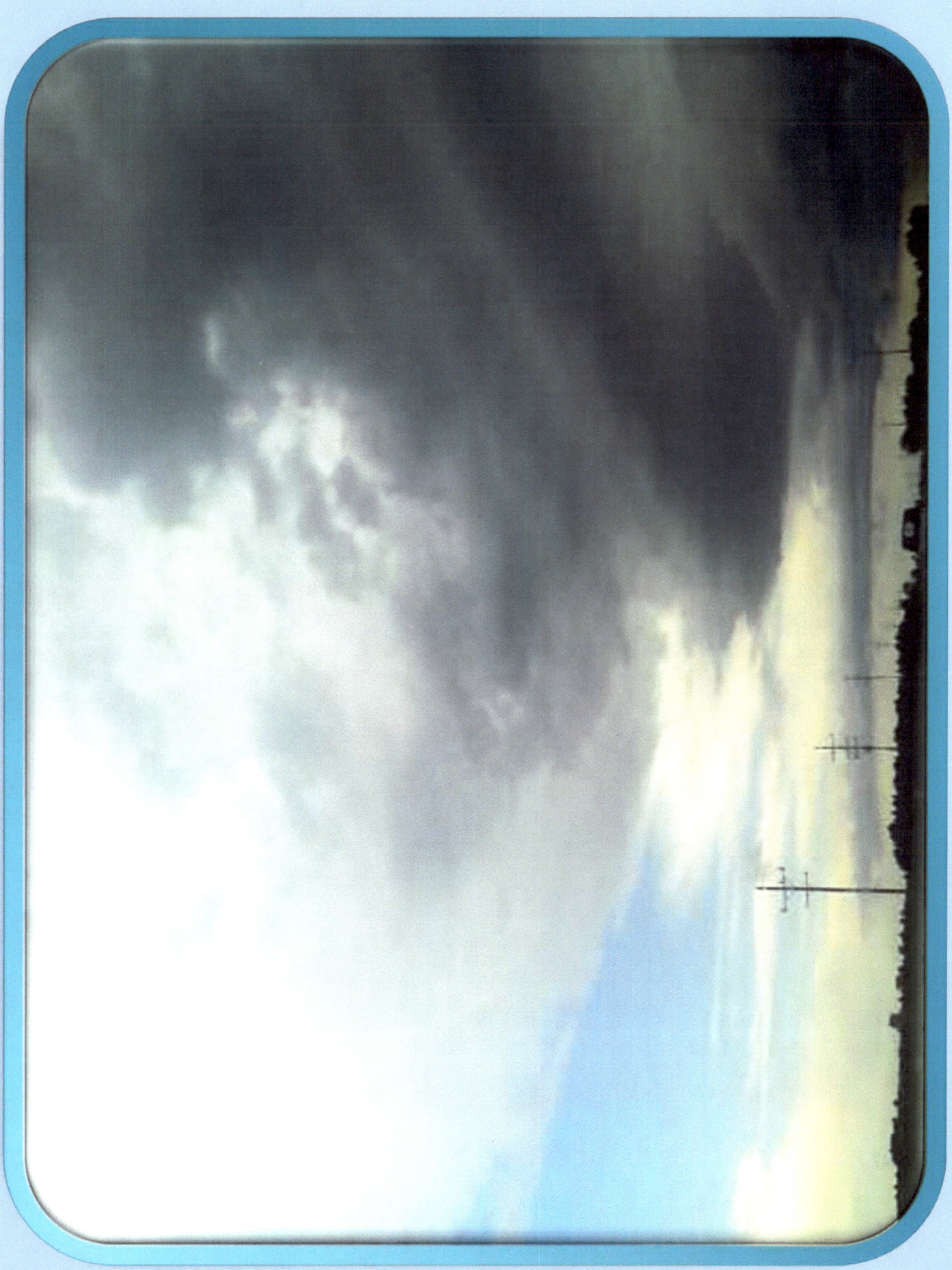

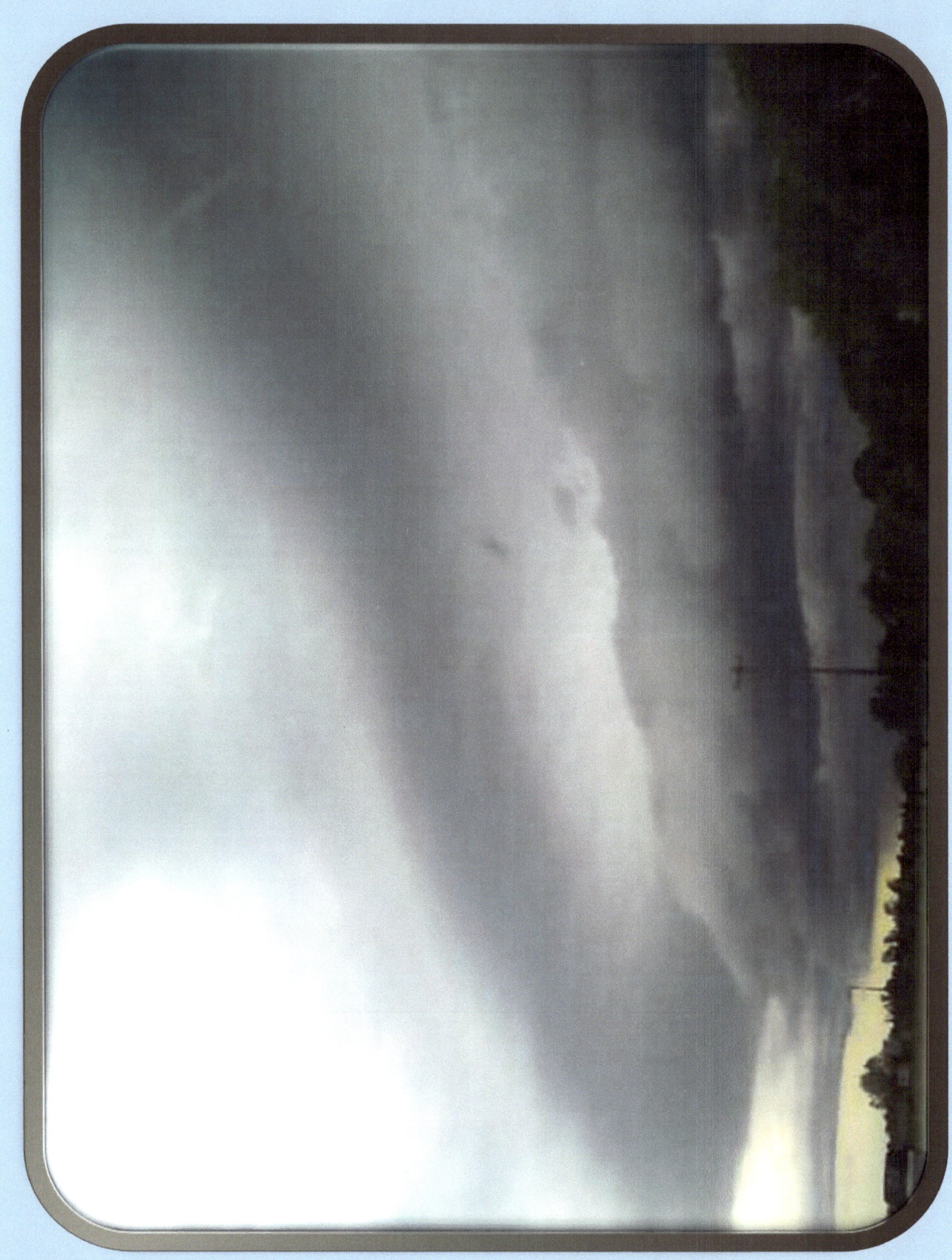

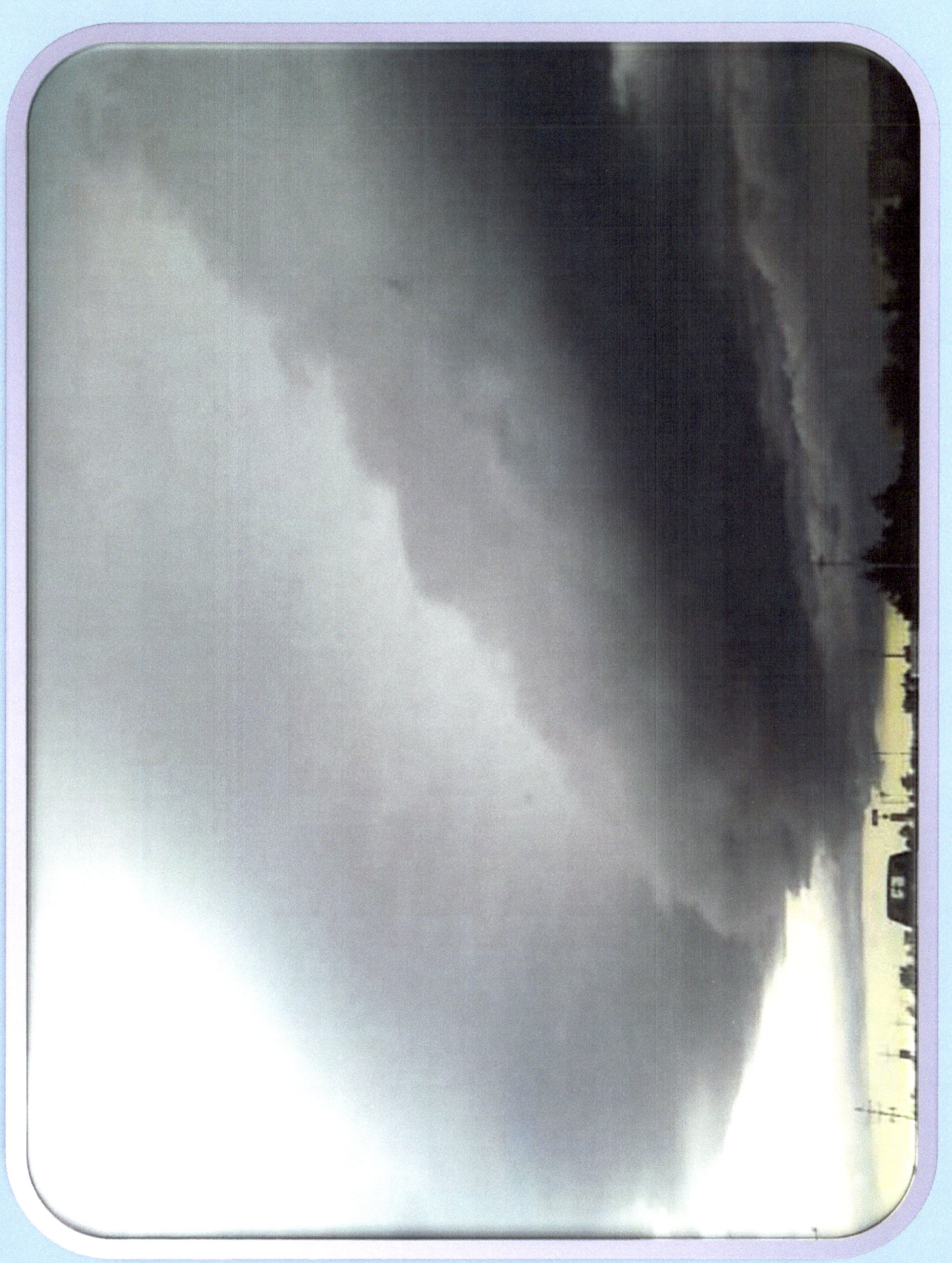

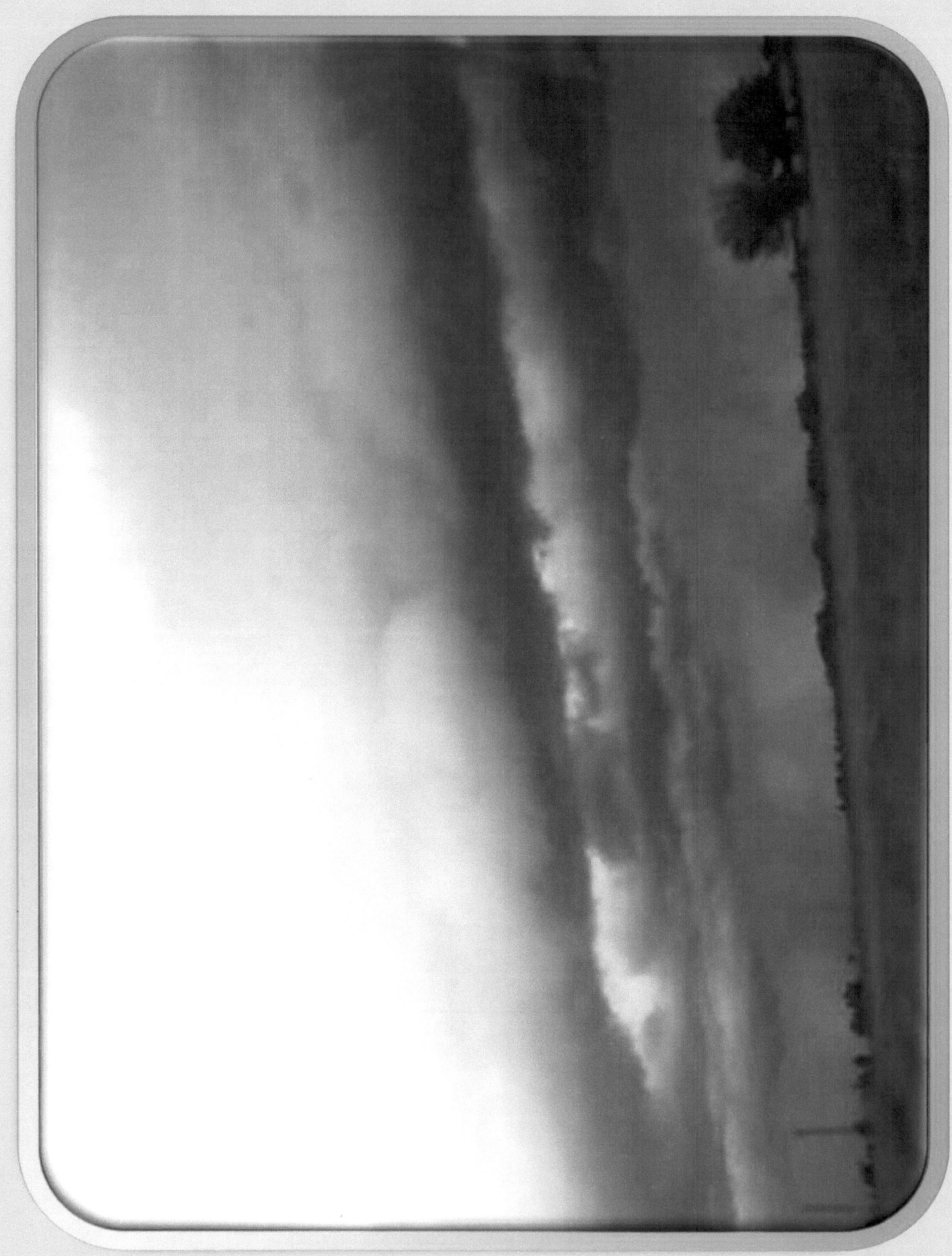

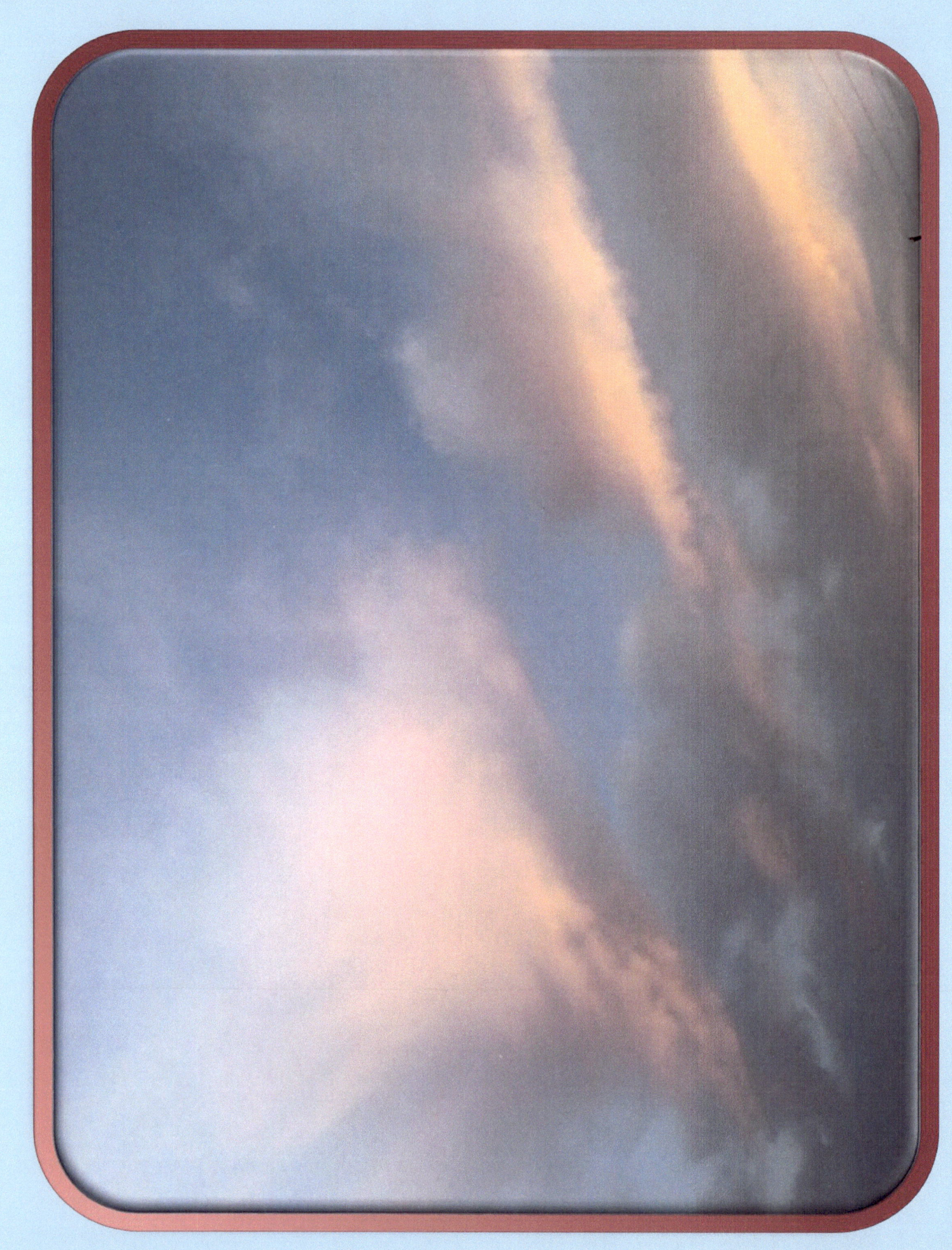

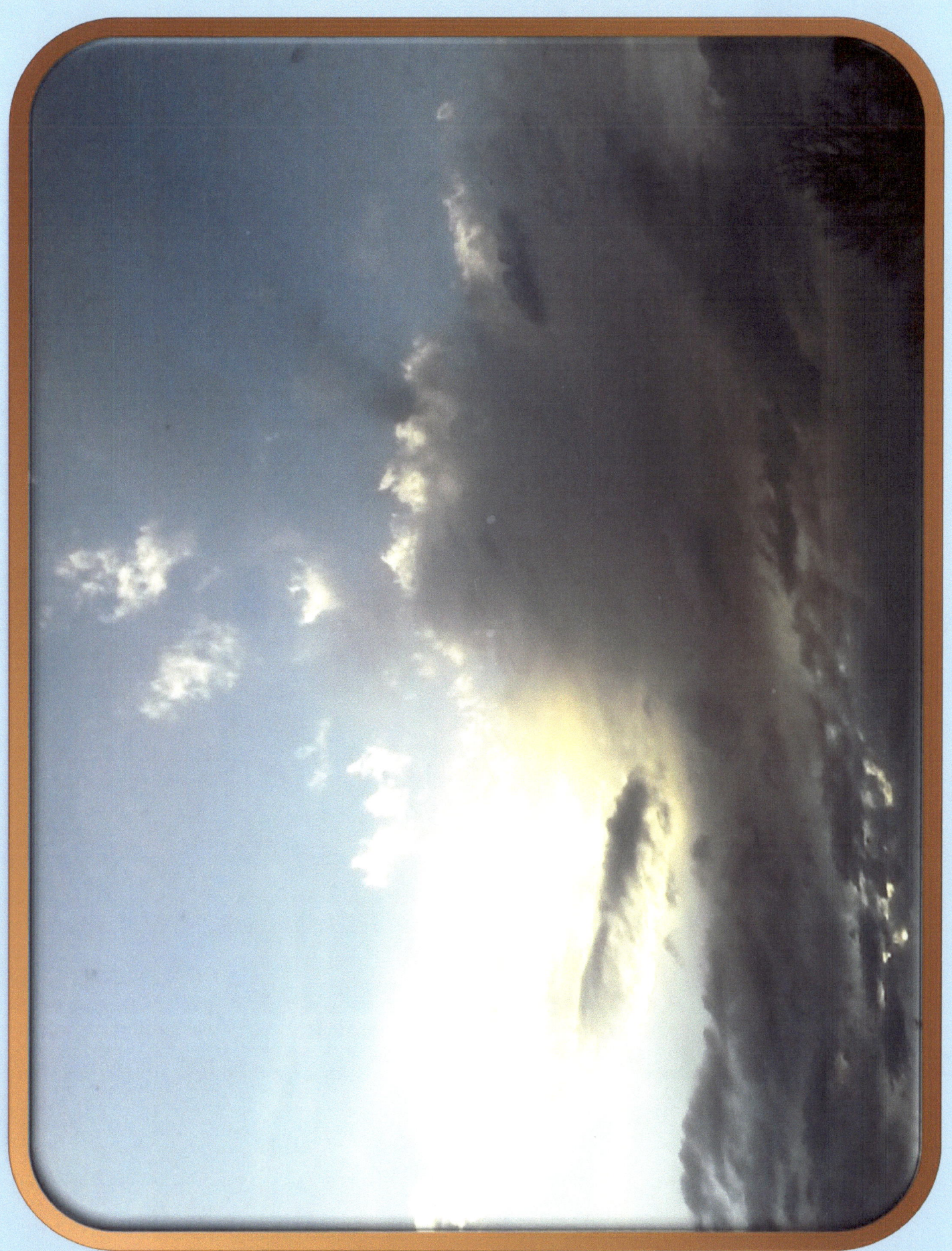

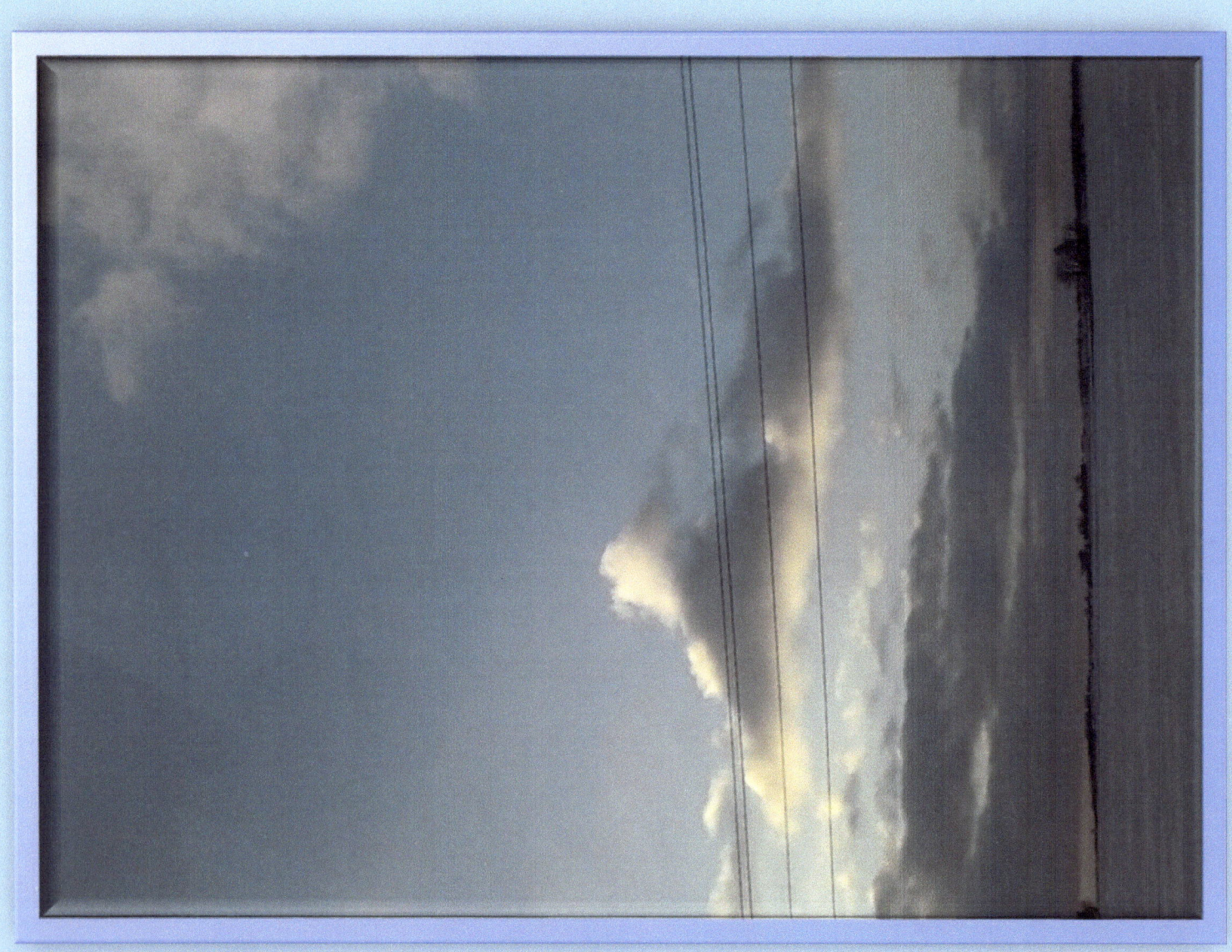

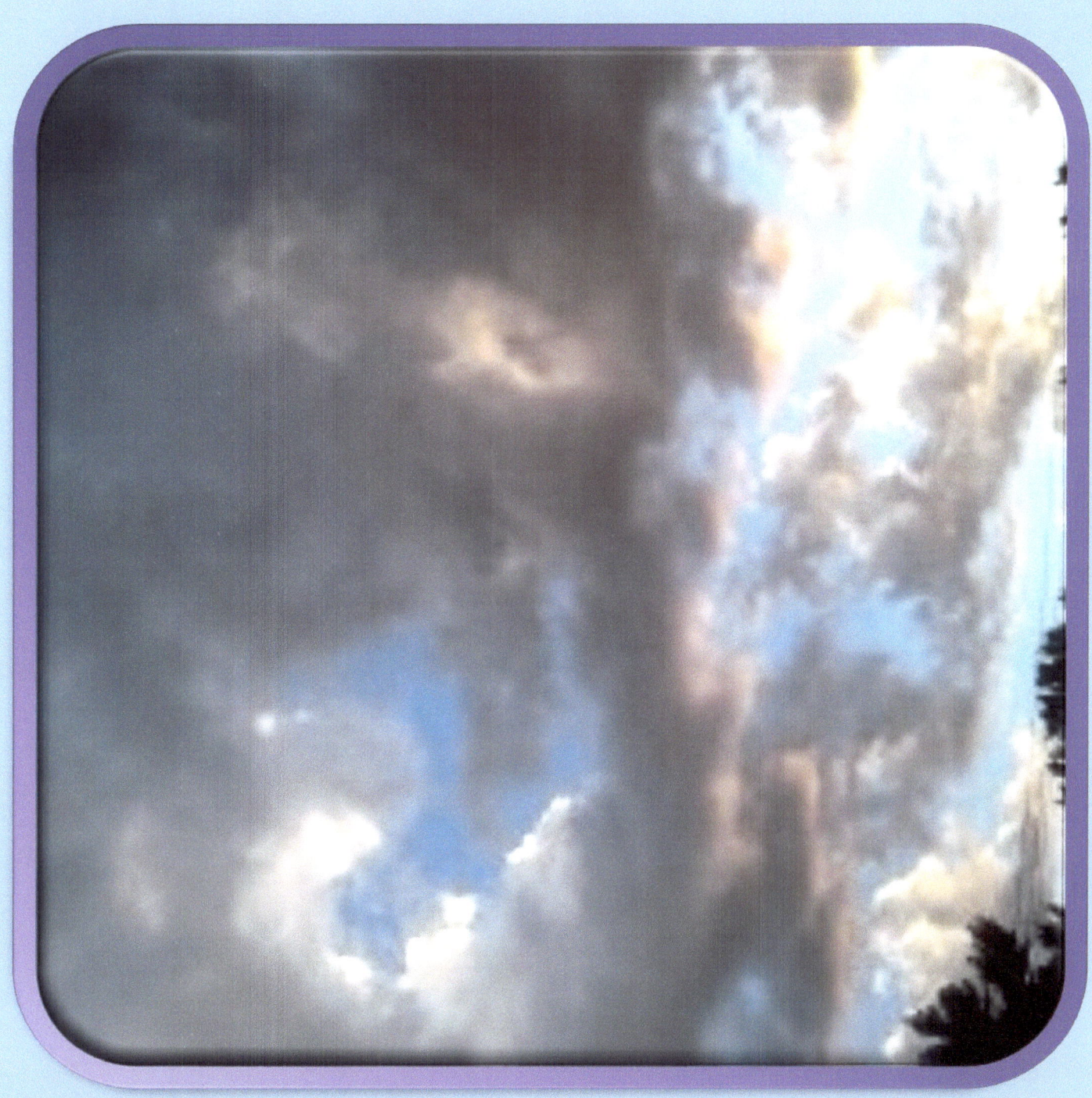

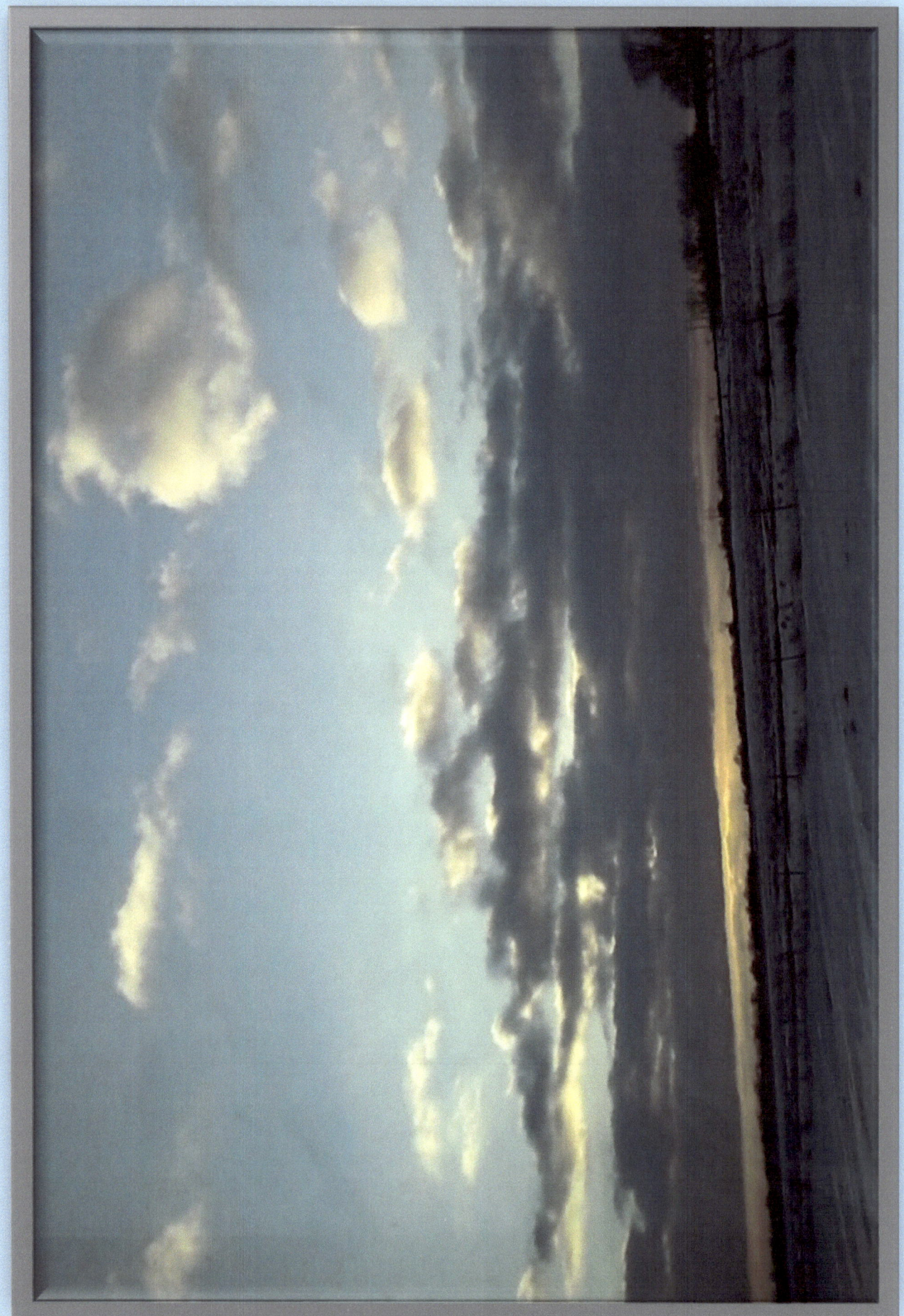

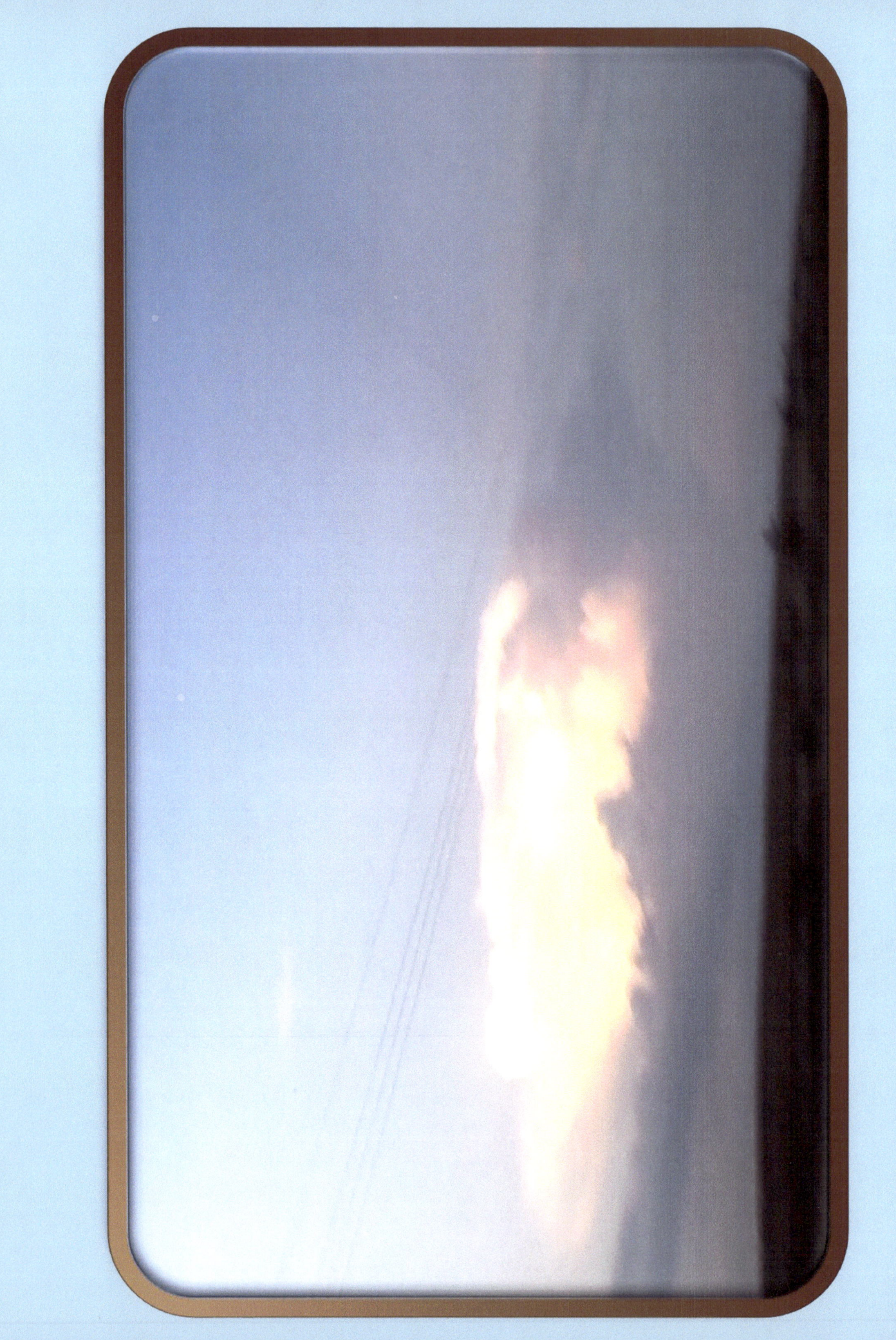

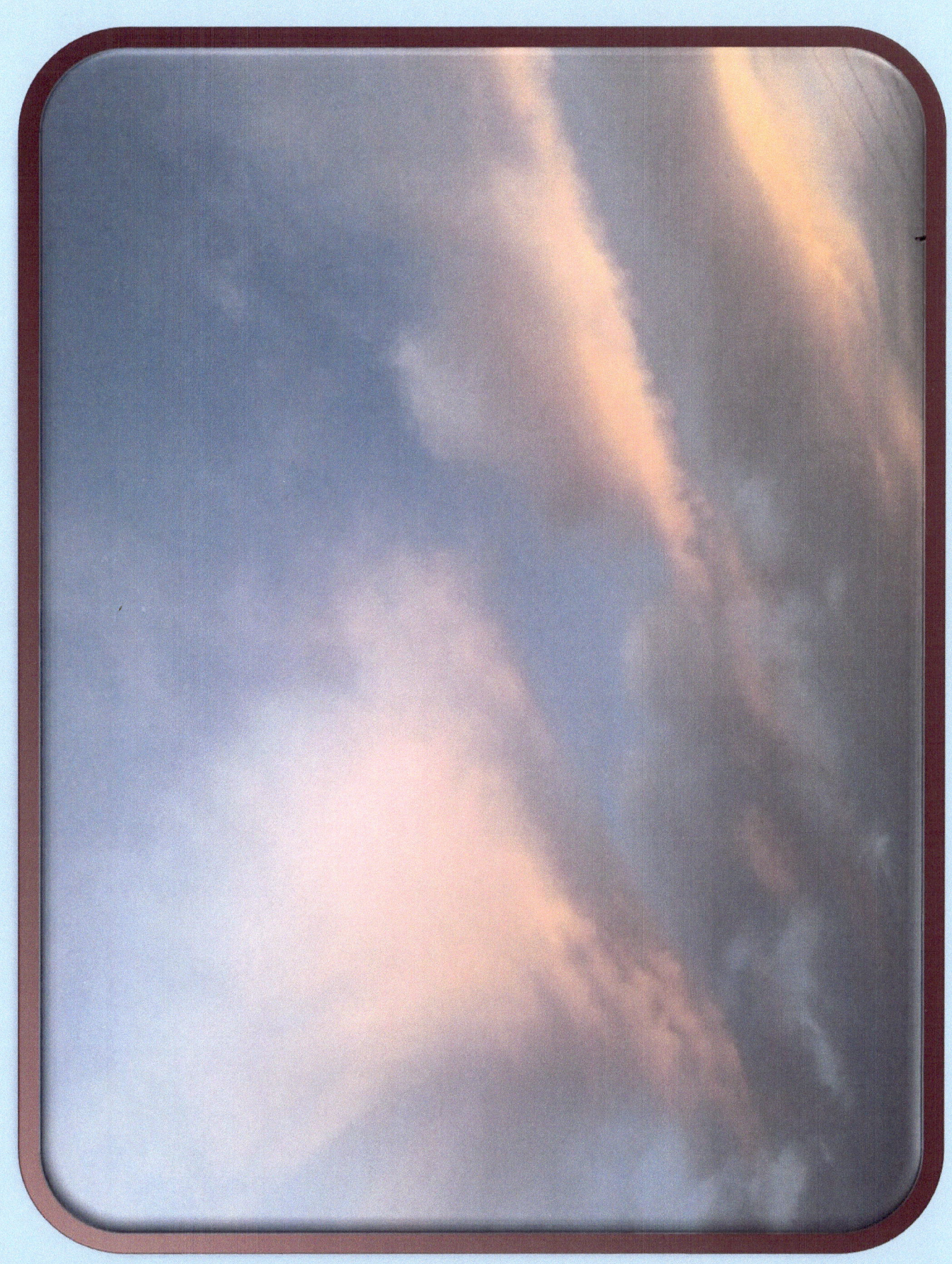

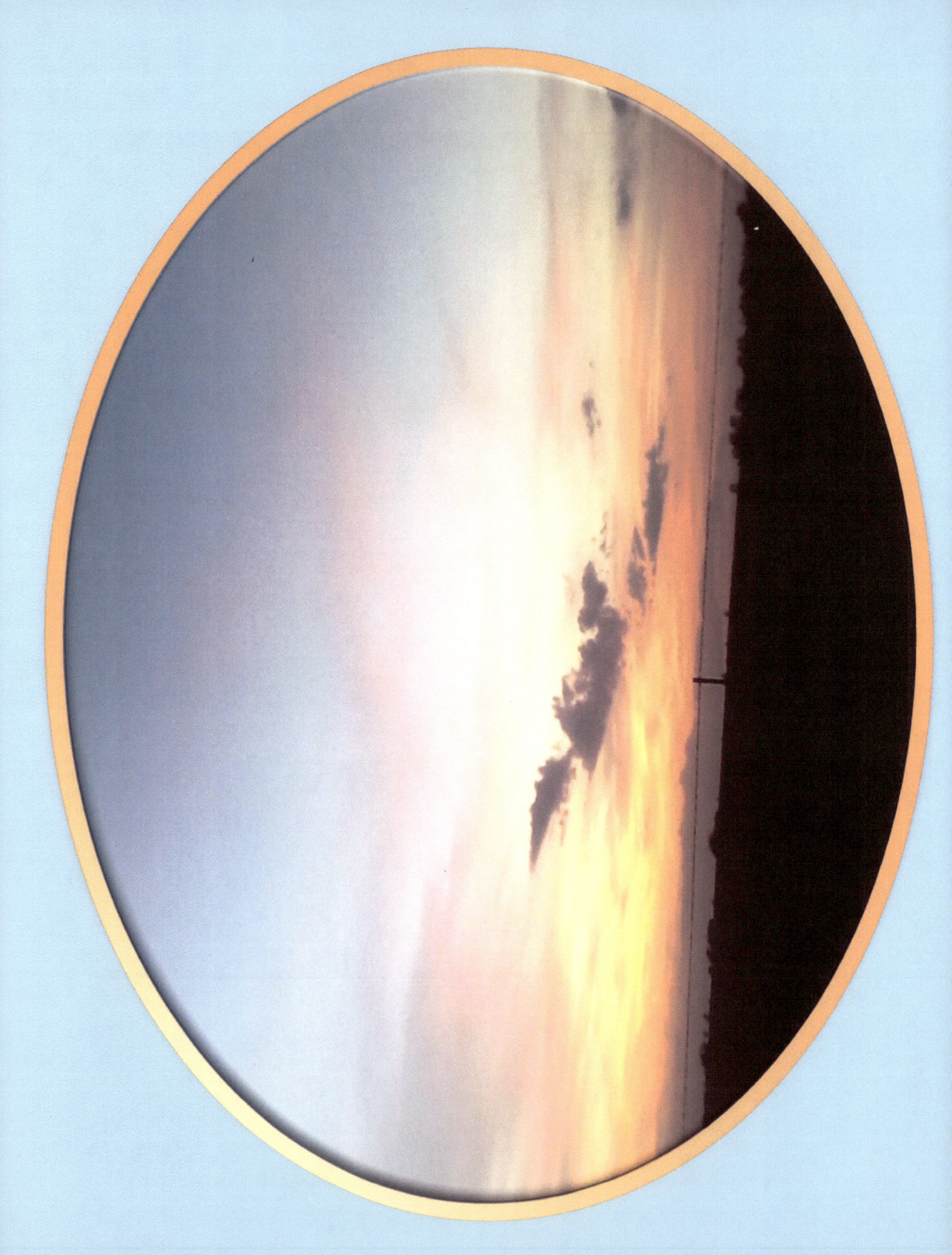

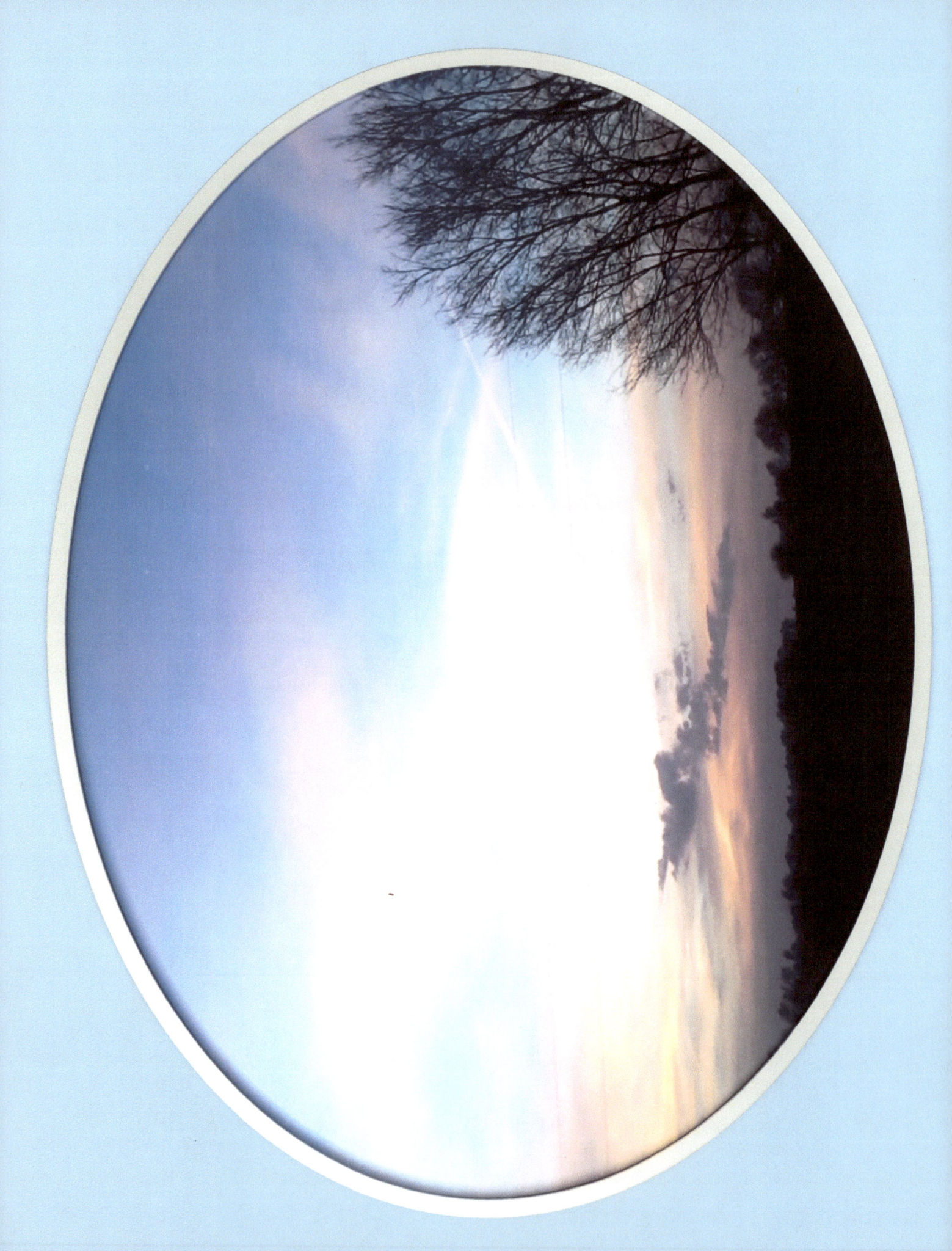

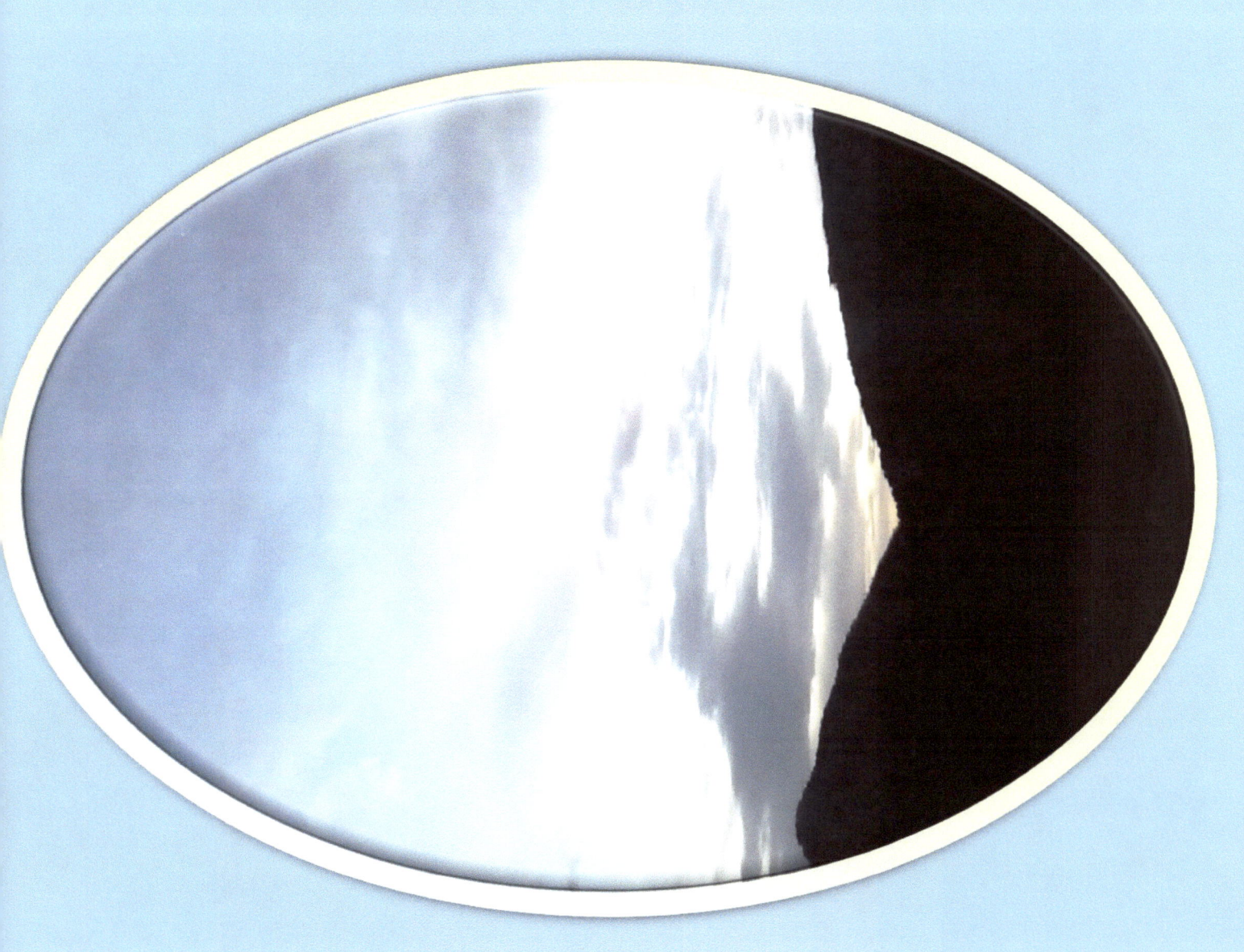

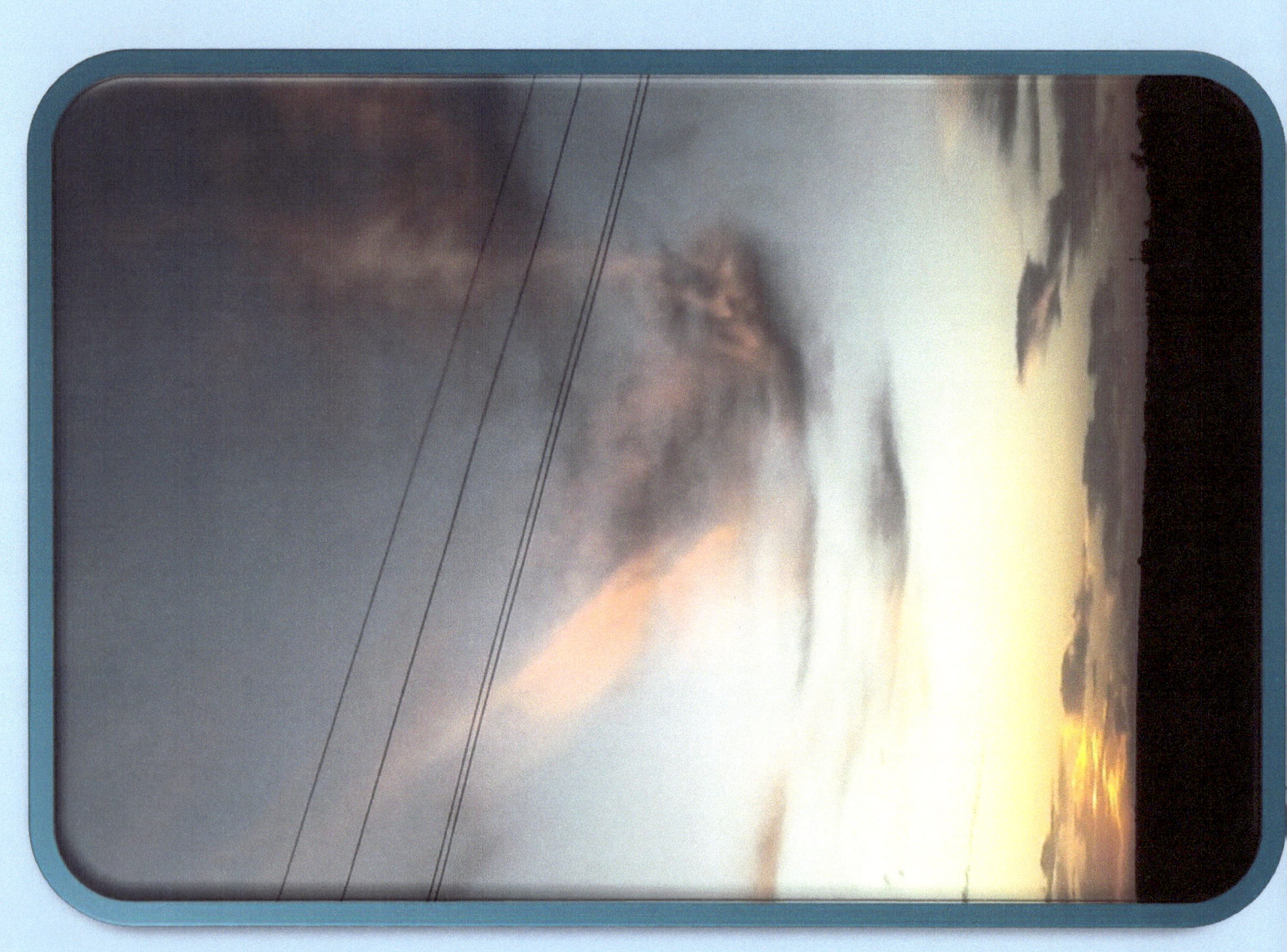

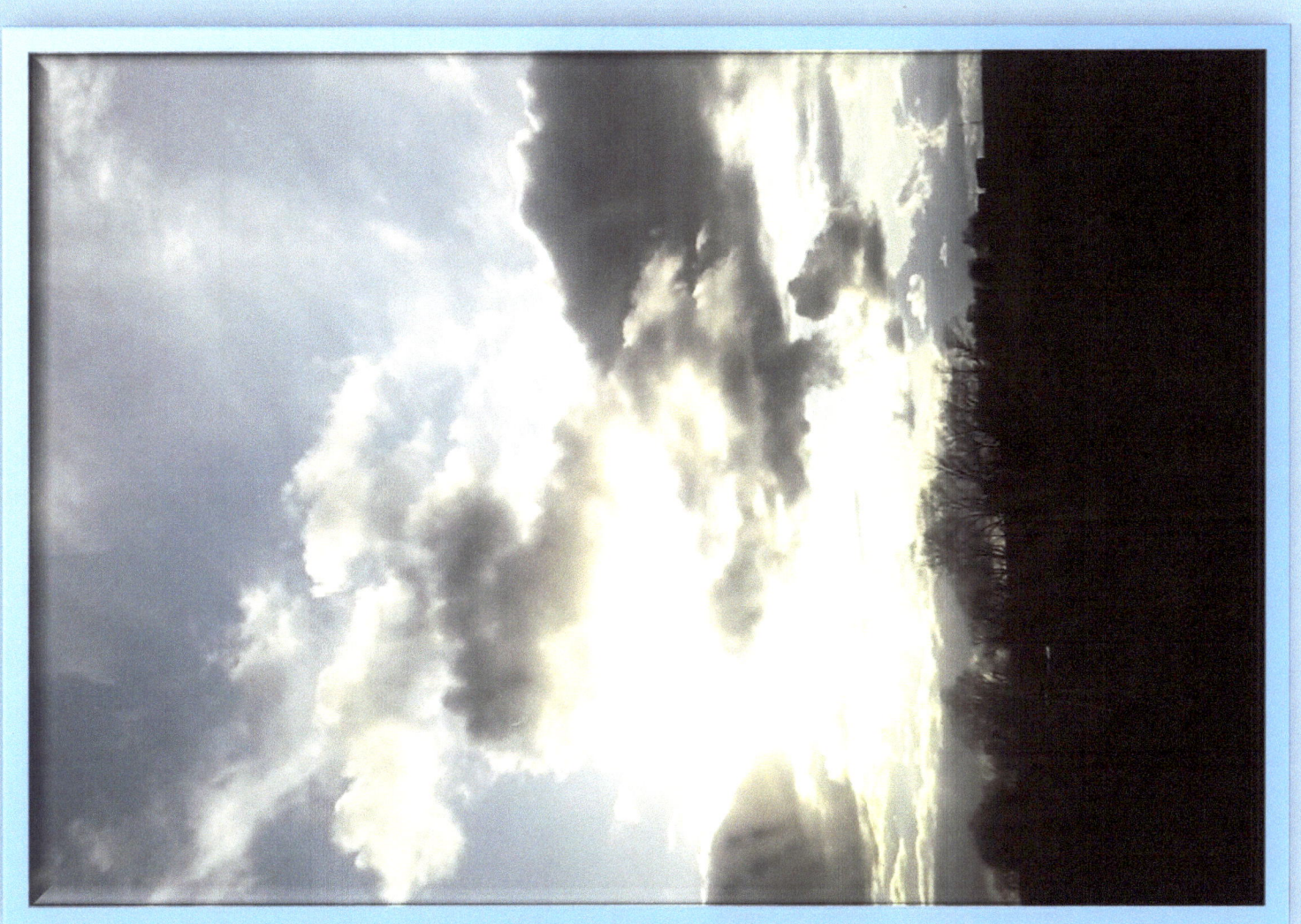

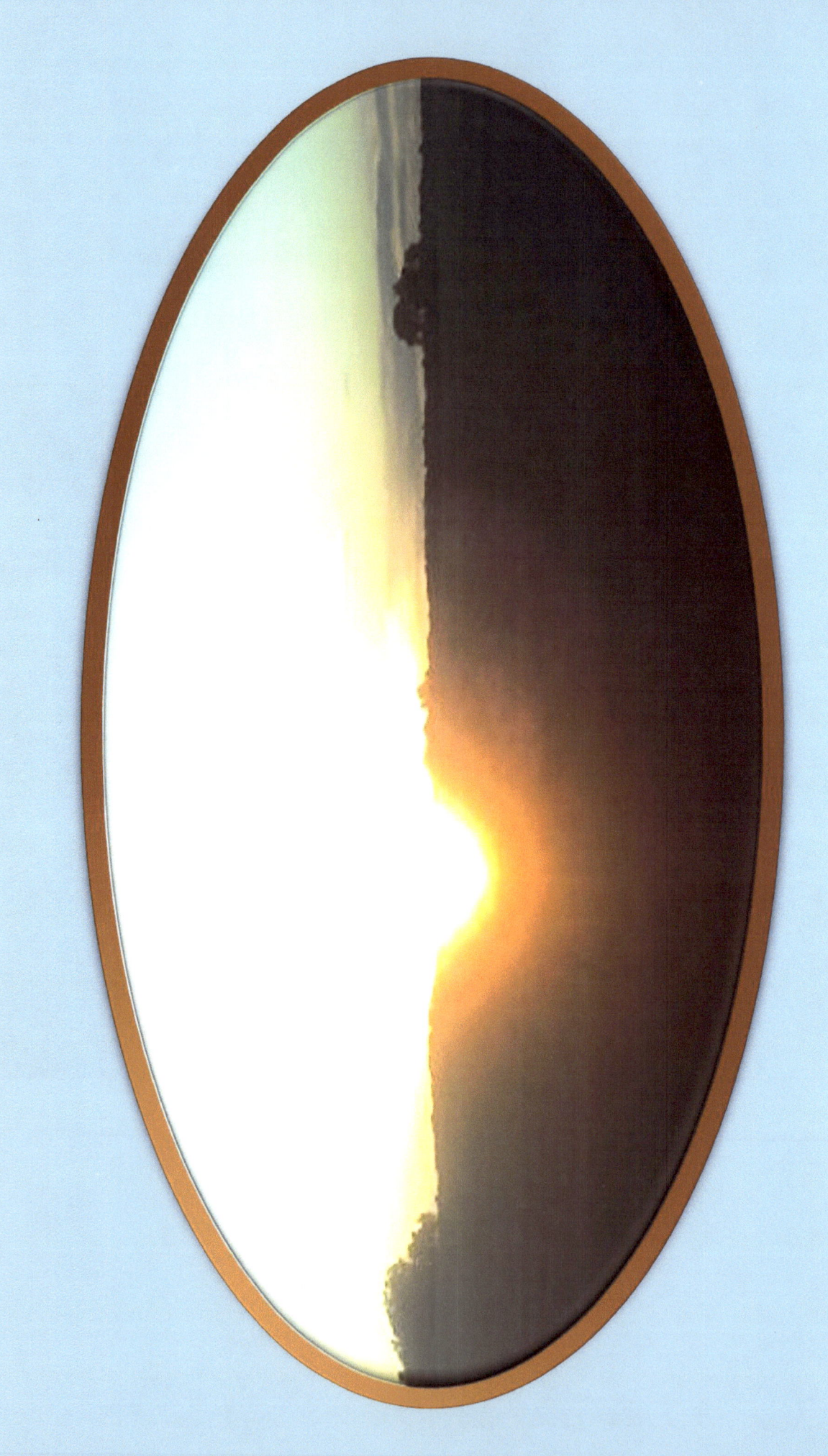

April Sanford-Meyer